Richard Dadd
(1817–1886)

Dreams of Fancy

A Loan Exhibition

Andrew Clayton-Payne

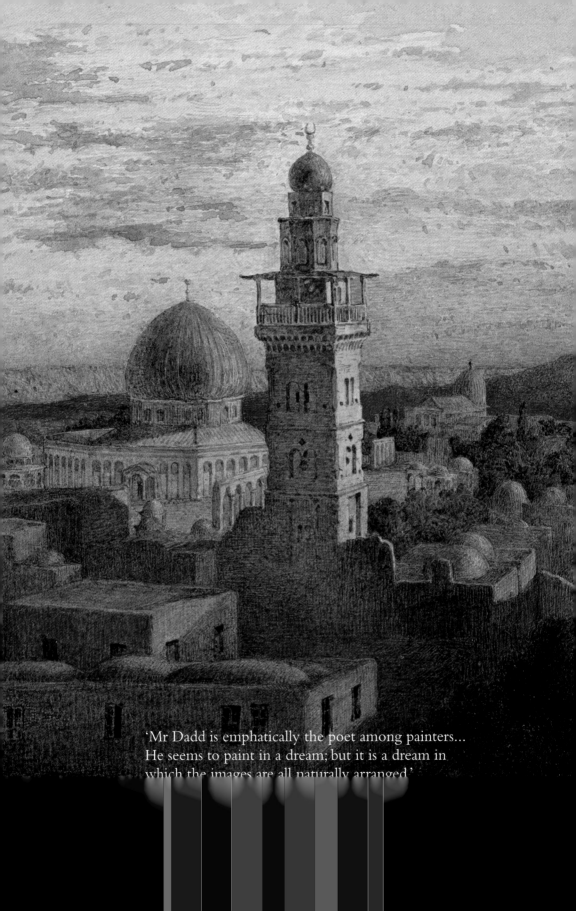

'Mr Dadd is emphatically the poet among painters...
He seems to paint in a dream; but it is a dream in
which the images are all naturally arranged'

Richard Dadd

(1817–1886)

Dreams of Fancy

A Loan Exhibition

Including works from the Bethlem Royal Hospital

2nd July – 11th July 2008

Catalogue written by Patricia Allderidge

Catalogue sold in aid of
Bethlem Art and History Collections Trust

Andrew Clayton-Payne

14 Old Bond Street, London W1S 4PP

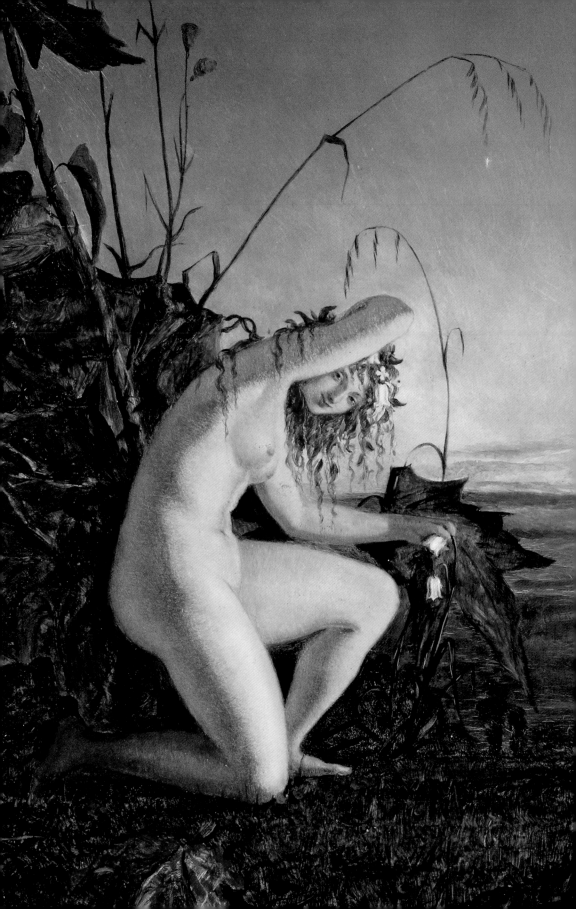

Foreword

Some years ago, I read a transcript of a letter written in 1843 by Richard Dadd's patron Sir Thomas Phillips to David Roberts, after Dadd had murdered his father. He expresses his 'sorrow for the afflicting fate of the unhappy father, sympathy for the bereaved and suffering family and deep commiseration for the unconscious agent of so much misery...' One could not be but struck by the compassionate tone of his sentiments but also by his enlightened attitude to criminal insanity. And this is perhaps one of the things that makes Dadd's art so interesting, that his journey from sanity to insanity can be seen not only in his art, but also against the backdrop of mid 19th-century society.

A seemingly unrelated event became the catalyst for this exhibition. My acquisition of Dadd's *Jerusalem from the House of Herod* put me back in touch with Patricia Allderidge, the Archivist and Curator at the Bethlem Royal Hospital from 1967–2003, whose Richard Dadd exhibiton at the Tate in 1974 is still considered to be the Holy Grail for Dadd devotees and scholars alike. A chance remark to Patricia made us consider the possibility of putting on a small but focused exhibition of Dadd's work. Thanks entirely to her drive, enthusiasm and commitment (not to mention her humour) this exhibition has gestated from an idea to reality in record time. Her encyclopaedic knowledge of Dadd's life and work is astonishing and I was delighted when she agreed to write the catalogue. I would also like to thank Patricia for her suggestion to borrow pictures from the Bethlem Royal Hospital.

Michael Phillips, Head of Archives and Museum at Bethlem Royal Hospital, responded very positively when I first proposed the idea of borrowing a group of Dadd's watercolours for the exhibition. He has worked hard and with great efficiency to make sure that the loan has gone smoothly. He has met my persistent demands with both patience and tolerance. I am most grateful to him and to the Trustees of the Bethlem Art and History Collections Trust for agreeing the loan.

I would also like to thank everyone else who has helped make the exhibition possible. I am especially indebted to Cosima Pavoncelli, Rhoda Eitel-Porter, James Perkins, Briony Llewellyn, Eric Shanes, Diana Cawdell, Tim Harvey, Helen Beastall, Andrew Hardy, John Falconer, Matthew Hollow and Gino Franchi. Finally, a special thank you to the Morgan Library & Museum for allowing me to exhibit *Jerusalem from the House of Herod* and to the anonymous owners who have so generously allowed me to exhibit their works.

Andrew Clayton-Payne
July 2008

opposite
Richard Dadd (1817–1886) *The Haunt of the Fairies* c.1841 (detail), oil on panel 9 × 7½ in (23 × 19 cm)

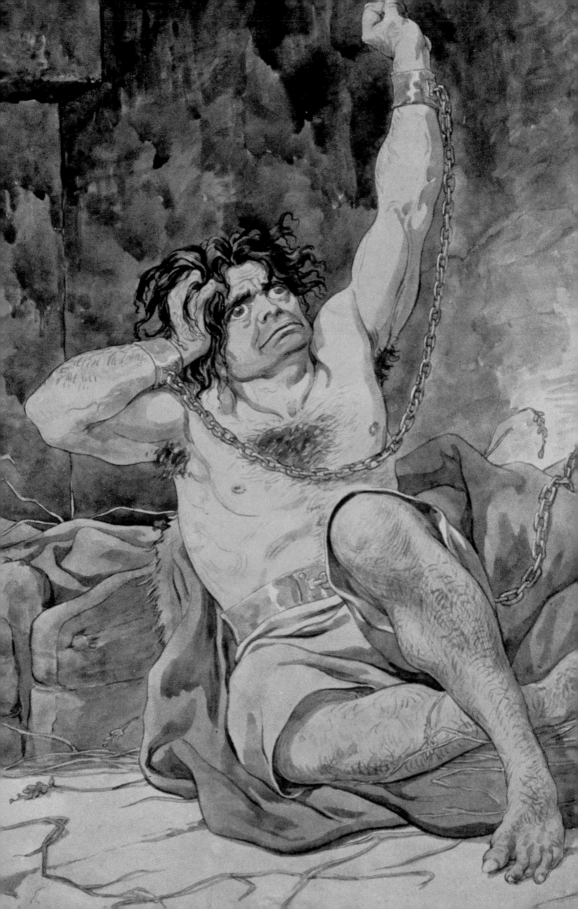

Art at Bethlem

The Bethlem Hospital which Richard Dadd knew is now the Imperial War Museum. Bethlem Royal Hospital moved in 1930 to Beckenham, now in the London Borough of Bromley. Dadd's patient records and 40 of his works are in the care of the Bethlem Art and History Collections Trust, located in the hospital grounds. Housing archives from 1559 onwards, the archive depository is now full. The little museum which was created three decades ago can display only a small part of the Trust's art collection of nearly a thousand artworks. Over the past four years on-site audiences have more than doubled and off-site audiences in one year reached 41,000. Dedicated education space is also needed for the 35 school parties who visit each year.

The archives and museum are moving to another larger building on the Bethlem site. The aim is to open in late 2010. With two-thirds of the funding now in place, Bethlem Art and History Collections Trust is seeking to raise the final £500,000 to complete Britain's first full-time archives and museum dedicated to the understanding of mental illness.

Bethlem Art and History Collections Trust is grateful to Andrew Clayton-Payne for exhibiting some of the paintings for which we are building a new home and for sponsoring the launch of our relocation project.

J. MICHAEL PHILLIPS
Head of Archives and Museum
Bethlem Royal Hospital

opposite
RICHARD DADD (1817–1886) *Sketch to Illustrate the Passions. Agony – Raving Madness* 1854 (detail), watercolour 14 × 9¾ in (35.5 × 25.3 cm)

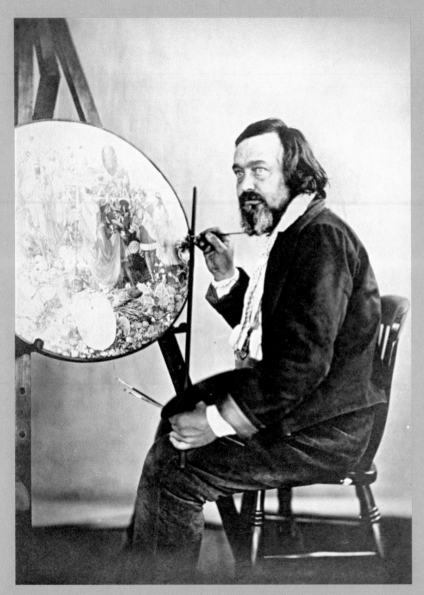

Richard Dadd in Bethlem Hospital in the 1850s, at work on *Contradiction. Oberon and Titania*

Chronology

1817 1 August. Richard Dadd is born in Chatham, Kent, the third son and fourth child of Robert Dadd, chemist and druggist, and his wife Mary Ann Martin. Both parents are from families with a long history of skilled work in the Royal Naval Dockyard and seafaring.

1824 His mother dies aged 34, leaving four sons and three daughters.

1826 Robert Dadd marries Sophia Oakes Munk of Ryarsh, a village near Maidstone. She dies six years later, leaving two more sons.

1827 Admitted to the King's School, Rochester (the Cathedral Grammar School) which he attends until 1831, learning Latin and Greek. He begins drawing seriously around the time when he leaves school, strongly influenced by the countryside around his home, and the shipping on the River Medway.

1834 Moves with his family to London, living at 15 Suffolk Street, Pall Mall East, where Robert Dadd has taken over the business of gilding and ormolu manufacture from his brother-in-law, André Picnot.

1837 Admitted to the Royal Academy Schools as a probationer in January, and a full student in December, after a period of drawing from antique statues at the British Museum. Fellow students and friends include Augustus Egg, John Phillip, William Powell Frith and others with whom he later forms a sketching club known as 'The Clique'. Exhibits his first work, *Head of a Man*, at the Society of British Artists.

1838–9 Wins medals in the School of Painting and the Life Class at the Royal Academy. Exhibits at the Society of British Artists, the British Institution, and the Royal Academy, beginning with landscapes, seascapes and portraits, and moving on to scenes from literature. Makes his first sale with a scene from *Don Quixote*.

1840 Wins silver medal for first prize in the Life Class. Exhibits Shakespearean scenes from *Hamlet* and *As You Like It,* and scenes from English history, at the Royal Academy and other galleries.

1841 Exhibits two scenes from *A Midsummer Night's Dream* which help to establish his reputation as a painter of fairy subjects, *Titania Sleeping* (now in the Louvre) and *Puck*. Commissioned to paint a series of panels for Lord Foley's house in Grosvenor Square, London, for which he chooses his own subjects from Tasso's epic poem *Jerusalem Delivered* and Byron's *Manfred*.

1842 Exhibits a fairy painting at the Royal Academy based on Ariel's song, 'Come unto these Yellow Sands', from *The Tempest*, said to be 'one of the attractions of the exhibition'. Becomes a founder member of the Painters' Etching Society. Illustrates 'The Ballad of Robin Goodfellow' for *The Book of British Ballads.* David Roberts RA, a friend of his father, recommends him to accompany Sir Thomas Phillips on a tour of Europe and the Middle East as commissioned artist. Leaves England with Phillips on 16 July.

1842/3 Travels through Switzerland, north Italy, Greece, Turkey, Syria, Palestine and Egypt. Unable to complete many drawings due to the

speed of travel, but fills sketchbooks with outstanding examples of his draughtsmanship. Letters to Roberts and Frith show that he experiences early feelings of mental disturbance before reaching Egypt. Symptoms are first seen by Phillips during the return journey through Italy and France.

1843 May. Arrives home in haste from Paris after parting from Phillips, who has decided to seek medical advice. Is now suffering from delusions that he is pursued by devils, and that the Egyptian god Osiris is 'the supreme being' and controls his actions. Continues to work, and appears briefly to recover.
28 August. Stabs his father to death in Cobham Park, near Rochester, believing him to be the devil in disguise. Escapes to France, and is arrested after trying to kill a stranger in a carriage. Committed to an asylum at Clermont. His younger brother, who has also shown symptoms of insanity, is admitted to Bethlem Hospital in September.

1844 July. Extradited from France and appears before the magistrates at Rochester to be committed for trial for murder. Certified insane before trial and ordered to be detained 'until her majesty's pleasure shall be known' in the state criminal lunatic asylum, which is housed at Bethlem Hospital in London. Admitted to the 'criminal department' at Bethlem, a prison-like block at the back of the main hospital building, on 22 August, aged 27.
24 September. His friend the painter John Phillip marries Dadd's youngest sister, whose own insanity eventually leads to her confinement in an asylum.

1845 Report published in the *Art Union* that he has recently been making drawings of landscapes and scenes from his Middle Eastern travels which show 'all the power, fancy and judgement' of his previous work, using a small sketchbook which he has with him in Bethlem. *Artist's Halt in the Desert* is now known to date from this period.

1845/64 Continues to paint throughout his time in Bethlem, working in oil and watercolour, and covering the same subjects as before: landscapes and seascapes, scenes from history and literature, portraits, and scenes and reminiscences from his early life, often incorporating material from his Middle Eastern travels. Works on a long series of *Sketches to Illustrate the Passions*, mainly in 1853/4. Paints two more fairy subjects, *Contradiction. Oberon and Titania* and *The Fairy Feller's Master-Stroke*, each taking several years to complete and now considered to be his masterpieces.

1857 Dadd is moved, along with some other criminal patients, from the bleak and overcrowded environment of the criminal lunatic department to a more comfortable ward in the main hospital, though still kept in close confinement.
Six of his works, including *Artist's Halt in the Desert* and two other watercolours from Bethlem are included in the exhibition *Art Treasures of the United Kingdom* at Manchester.

1864 All criminal patients are transferred to the newly built state criminal lunatic asylum at Broadmoor in Berkshire, which replaces the accommodation at Bethlem and provides a less restrictive environment. Built on a hill top, it has terraces with views over the surrounding countryside.

1864/86 Still mainly occupied in painting, Carries out various decorative projects, including drop curtain and stage scenery for the Broadmoor theatre and a mural in the physician superintendent's house. Reads classical literature, plays the violin, and takes an interest in mythology and religion, but retains his delusions and still believes that he is persecuted by devils.

1870 Thirty three of his works are sold at auction after the death of Sir Charles Hood, former physician superintendent of Bethlem Hospital. Many are bought by dealers and collectors.

1876 *Sketch to Illustrate the Passions. Recklessness* is acquired by the British Museum, the first of his works to enter any national collection.

1877 Is interviewed in Broadmoor by an unidentified writer, who publishes a detailed account of the meeting in *The World*. Two watercolours, *Tombs of the Khalifs* and *Entrance to an Egyptian Tomb* are the first of his works to be acquired by the Victoria and Albert Museum.

1883 Completes his last known work, *Tlos in Lycia*, a watercolour based on a sketch made during his travels forty years earlier.

1886 8 January. Dies of consumption, and is buried in the cemetery within the grounds of Broadmoor.

1892 A sketchbook from his travels with Sir Thomas Phillips, formerly owned by Phillips, is bought by the Victoria and Albert Museum.

1915 The watercolour *A Turk* is the first of his works to be acquired by the Tate Gallery.

1919 *Port Stragglin*, one of the finest examples of his Bethlem watercolours, is given to the British Museum in memory of Robert Ross.

1963 *The Fairy Feller's Master-Stroke* is given to the Tate Gallery by Siegfried Sassoon in memory of the painter's great nephews. For many years the only work by Dadd to be on public display, it is thought to be typical of all his output, and still remains his most famous painting.

1974 The Tate Gallery's touring exhibition *The Late Richard Dadd*, shown in London, Hull, Wolverhampton and Bristol, introduces his work to a wider audience

1983 *Contradiction. Oberon and Titania* is sold at auction for a record price for a Victorian painting

1987 *Artist's Halt in the Desert*, a scene from his Middle Eastern travels, is rediscovered through the Antiques Roadshow, revealing the exceptional quality of his early watercolours. Bought by the British Museum, it is now one of his best known works after *The Fairy Feller's Master-Stroke*.

2007 A rare watercolour made in the course of his travels or immediately afterwards, *Jerusalem from the House of Herod*, is rediscovered and provides further evidence of his outstanding skill in this medium.

Memories and Dreams of Fancy

'I hope I shall reap all the advantages I ought to do from this journey and I sometimes try to persuade myself I shall and am doing so. I work all I can and study all I can and with as concentrated an attention as I am capable of.'

Richard Dadd, letter to David Roberts RA from Malta, 24 February 1843

When he wrote these words to Roberts in the course of his tour of Europe and the Middle East, Richard Dadd was still technically a student at the Royal Academy Schools, being only about halfway through the ten year period for which a studentship then lasted. He had won several prizes for his work in the Schools and built up a reputation as the most dedicated, hard working and talented young artist of his generation. He had already received critical acclaim as a painter of imaginative subjects, particularly for his fairy paintings; his pictures were beginning to sell, and he had completed a major commission for a series of decorative panels for the town house of Lord Foley. Now he was on the final leg of the journey which had been facilitated for him by Roberts, from which he was expected to return with material enough to carry him through years of future success. And he was also in the early stages of the catastrophic mental breakdown which six months later would end his professional career, and to all intents and purposes, in the eyes of his contemporaries, his life too, at the age of twenty six.

And yet less than a third of the drawings in this exhibition had been made by the time the letter was written, and the vast majority of all the works for which he is known and admired today were produced in the forty or so years which followed. It is nearly as difficult now to imagine how he managed to overcome the overwhelming odds against him, as it was at the time for those around him to guess that he would do so, but some of the answer must lie in his own words to Roberts: 'I work all I can and study all I can and with as concentrated an attention as I am capable of.' Once his incarceration

RICHARD DADD (1817–1886) *General View of Part of Port Stragglin*, 1861, watercolour 7½ × 5½ in (19 × 14 cm). © The Trustees of the British Museum

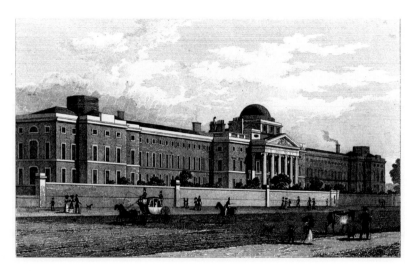

Bethlem Hospital at St George's Fields, Southwark, as it appeared when first built in 1815. Accommodation for the criminal patients was in a detached block at the back of the building.

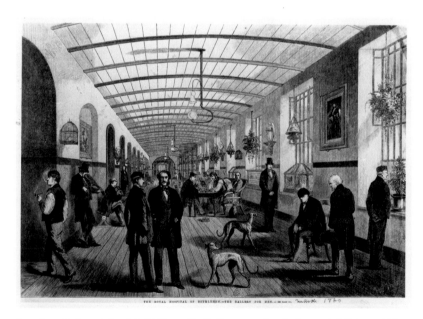

A men's ward in the main hospital at Bethlem, 1860. Dadd was moved in 1857 to a ward of this type, which was converted to provide security, and segregation from non-criminal patients.

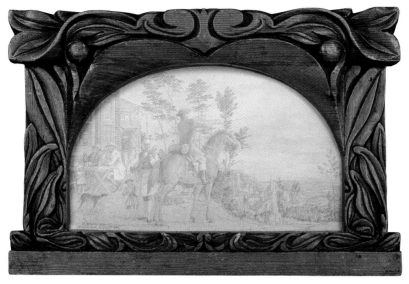

RICHARD DADD (1817–1886) *A Wayside Inn*, 1871, watercolour 4¾ × 8½ in (12.5 × 21.5 cm).
© Bethlem Art and History Collections Trust

in Bethlem Hospital had begun there was not much possibility of further study, but he could cling tenaciously to the training and experience which he had amassed up to that time. Having always done everything with as concentrated an attention as he was capable of, he was somehow able to pick up his work where he had left off, and despite the most adverse circumstances, he did continue for the rest of his life to practice his profession. When he died in Broadmoor at the age of sixty eight, the registrar who wrote out his death certificate entered the words 'formerly an artist' under the heading 'occupation', and only the word 'formerly' could be disputed.

The influences and experiences which had helped to shape him as an artist, though hardly the artist he might have hoped and expected to become, began in his childhood. From his upbringing in the town of Chatham, dominated by the River Medway and the Royal Naval Dockyard, he acquired the enduring fascination with ships and shipping subjects which constantly resurfaces in his later work, sometimes merely glimpsed in tiny vignettes of river, sea or harbour which appear in the background to some other scene, but sometimes and most hauntingly treated as a subject in its own right, evoked from the depths of memory with almost mystical intensity. From the surrounding countryside of Kent he acquired another lifelong passion, the love of landscape. He began drawing seriously when he was about thirteen, and as the writer of his somewhat premature 'obituary' in the *Art Union* wrote in 1843, 'There is little doubt that he imbibed his early love of Art from his boyish acquaintance with the rich and varied scenery of his native county…'. An especially favourite sketching

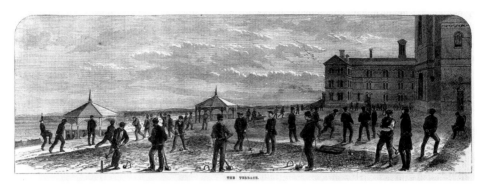

The Men's Terrace at Broadmoor, from the *Illustrated London News,* 1867

ground was Cobham Park, the large estate outside Rochester where, in a grotesque turn of fate, he would later persuade his trusting and affectionate father to come for a walk before murdering him.

It was probably his father who inspired his engagement with the world of nature at close quarters, minutely observed as if through a magnifying glass and lovingly recorded, which is a feature of all the fairy paintings but particularly the later ones. Though a chemist by trade Robert Dadd was a keen amateur geologist, and as the founding curator of the local museum he built up a substantial geological and natural history collection. A strong believer in the importance of education, he would certainly have encouraged all his children to share these interests and to study the world around them, and Dadd seems particularly likely to have responded to such an influence. Wherever or however he may have first learnt his technical skills in painting and drawing, there is no doubt that from an early age he was practising some of the techniques of miniature painting, particularly the use of hatching and stippling; and as a natural miniaturist who always worked instinctively on a small scale and painted with a sharply focussed precision, he must also have developed the habit of close observation.

In his more formal education, he was the only member of his family to attend the Cathedral Grammar School at Rochester, where he learnt Latin and Greek and acquired an interest in classical literature and mythology which he was still pursuing towards the end of his life in Broadmoor, and which also provided him with lifelong subject matter. This education may also have helped to develop his scholarly habits of mind, and the orderly and systematic approach to his work for which he was noted while a student at the Royal Academy. At home all the family shared a taste for English literature, from the plays of Shakespeare and the poetry of Byron to the ultra-modern novels of Charles Dickens which were beginning to appear from the mid-1830s on; and somewhere along the way he also learnt to play the violin.

After the move to London, his professional training at the Royal Academy developed his meticulous draughtsmanship through the old-fashioned method of drawing from plaster casts in the Antique School, calculated to encourage the students to strive for 'the ideal' before they were allowed to encounter the imperfections of nature in the Life Class. Even in the Life Class, however, painting from the living model had not yet been introduced and only drawing was allowed. Painting was taught only through copying the works of the Old Masters, and Dadd's later use of oils never moved beyond the limitations of the practices he had learnt during this period. Fortunately in his own exhibited work, he had spent just long enough on the approved repertoire of 'history painting' and scenes from literature, as well as more mundane themes, to acquire a useful store of subject matter, and the fairy paintings of 1841 and 1842 and his work for Lord Foley had enabled him to find and develop his true imaginative strengths.

It was the material garnered during his travels with Sir Thomas Phillips, however, which was to provide one of his most constant sources of inspiration, from his earliest work in Bethlem to the last known drawing which he made in Broadmoor. It is clear enough that throughout his time in the two institutions, Dadd was sustained by a phenomenal visual memory as well as the 'vivid and delicate imagination' for which

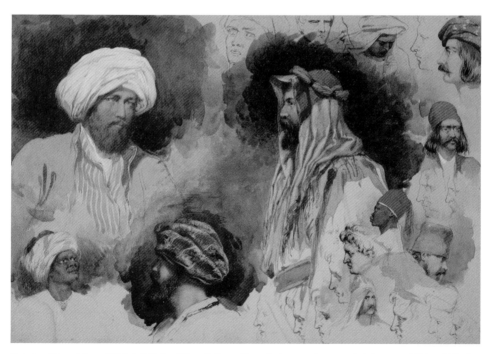

RICHARD DADD (1817–1886) *Portrait Studies of Figures in Eastern Dress*, 1842/3, watercolour 7 × 10 in (18 × 25.5 cm). Private Collection

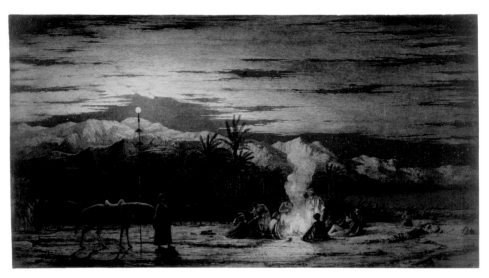

he had been noted and admired: but perhaps the most important factor of all was the sketchbook which he already had with him in Bethlem by May 1845, when he was seen working from it by a visitor, and which might even have been the trigger for his return to work. After the murder, Phillips had expressed a wish to have his travel sketchbooks in lieu of the drawings which Dadd would otherwise have made for him, and he certainly owned the one which can now be seen and marvelled at in the Victoria and Albert Museum, its pages packed with vivid, needle-sharp drawings of heads, figures, trees, camels, buildings, coastlines, glimpses of distant landscape, fragments of sculpture, and myriads of tiny skimming boats, some of them no more than a thumbnail in height. The 'small sketchbook' which accompanied Dadd on his forty-two year journey through memory and imagination, however, has not yet been found, but it has left the evidence of its existence in many places.

For a painter whose work had revolved so intensely round landscape and the natural world, it would be hard to envisage a more devastating fate than imprisonment without hope of release. Though there was some later improvement, for more than a decade after his first admission to Bethlem, Dadd's life was bounded by a locked cell, a long, narrow overcrowded day-room lit only by a small barred window at each end, and a bleak high-walled exercise yard. Deprived of light, colour, visual stimulus, and intellectual companionship, everything he had previously delighted in as a painter, there was nothing left to him but painting itself; and if the motivation had to come from his own inner resources, so too did his subject matter. Apart from the portraits, he seems never to have painted anything directly associated with his current

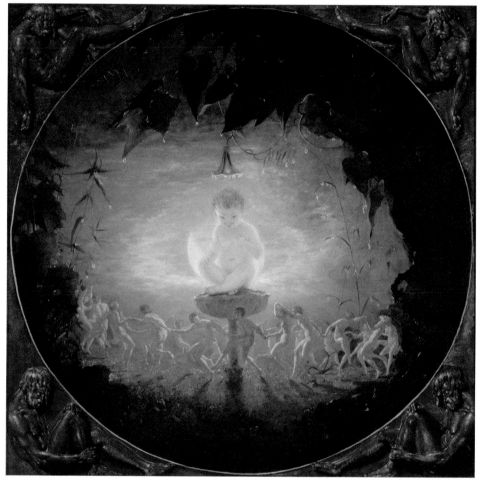

RICHARD DADD (1817–1886) *Puck*, 1841, oil on canvas 23¼ × 23¼ in (59.2 × 59.2 cm). Image courtesy of Sotheby's

environment or experience: the originality in his work is in the endlessly inventive reworking of the material which he brought in with him. Sometimes its origin is acknowledged in the title of a picture with the note 'A Reminiscence', but it could be said that all his work in Bethlem and Broadmoor is to a large extent based on reminiscence, whether of actual events or places, or of the sort of pictures he had painted before and of the costumes and details needed to flesh them out. And by the same token, although he reserved the title *A Dream of Fancy* for one of the most frag-ile and elusive of all his miniature landscapes, it is also true that 'dreams of fancy' would be an apt description for many if not all of his works from this period.

Richard Dadd

(1817–1886)

Self-Portrait 1841

Inscribed lower right 'Rd Dadd se ipse fecit.1841.'
Etching
5¼ × 4½ in (13.3 × 11.4 cm) (plate)

PROVENANCE
By descent in the family of the artist's brother
Capt. R.H. Dadd to 1972
Bethlem Art and History Collections Trust

This etching was made by Dadd from a small watercolour self-portrait. The two were not necessarily made at the same time, but the watercolour is inscribed on the back 'Richd Dadd at age 23', which would make them roughly contemporary if the age is correct. He has copied the watercolour directly onto the etching plate so that the print is a reverse of it, which may have been deliberate, since the self-portrait would itself have been made using a mirror. In any case the etching makes a particularly interesting comparison with the photograph of Dadd taken in Bethlem Hospital nearly twenty years later, which shows him facing in the same direction with his head at an almost identical angle, and with hair still worn in very much the same style.

Dadd was practising the technique of etching from at least 1840, when he designed and etched the frontispiece to *The Kentish Coronal*, a small volume of prose and poetry by 'persons connected with the county of Kent' which was edited by a friend (and probable relative) of the Dadd family in Chatham. He also made at least two other etchings, one of them an illustration for Gray's *Elegy in a Country Churchyard*, and was a founder member, together with a number of other artists in his circle, of the Painters' Etching Society in 1842. Around the same time he was designing wood engravings for the *Book of British Ballads*, and there is much about his work to suggest that he could have become an extremely fine illustrator if he had been able to pursue this course.

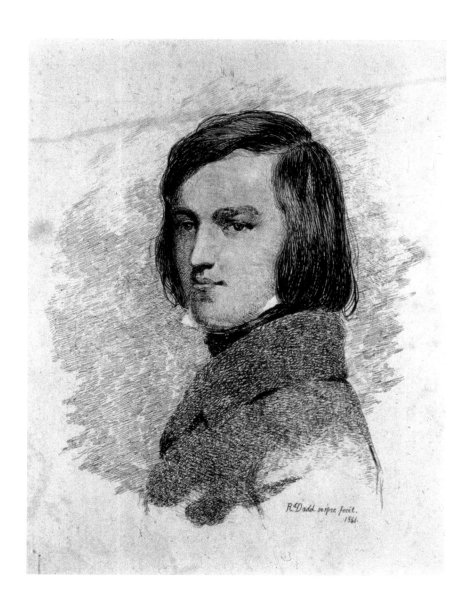

R.ᵈDadd seipse fecit.
1841.

Richard Dadd

(1817–1886)

Portraits of Elizabeth and Thomas Carter 1838

The first signed and dated lower right 'Rd Dadd 1838', the second signed lower left 'R Dadd'
Watercolour
7¾ × 5½ in (20.8 × 14.2 cm)

PROVENANCE

Bearne's, 8 March 1995, lot 550
Bethlem Art and History Collections Trust
(Purchased in 1995 with the help of a grant from the MGC/V&A Purchase Grant Fund)

These are typical examples of the many small informal watercolour portraits of family and friends which Dadd made in the late 1830s, and show his talent in portraiture as in so many other aspects of his work. Elizabeth Carter was the daughter of a naval officer living at Gillingham, near Chatham, and her husband Thomas worked for the dockyard and later had his own shipbuilding business at Poplar in London. Dadd's older brother Robert married the Carters' daughter Catherine in 1843, just 18 days before the murder of his father. Another daughter Elizabeth, also the subject of a portrait by Dadd, wrote to Broadmoor in 1879 'on behalf of the friends of Richard Dadd' to ask if he was still living, and she was later informed of his final illness and death, being the only contact then known to the Broadmoor authorities.

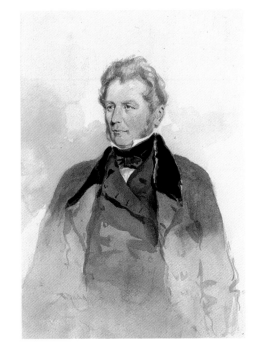

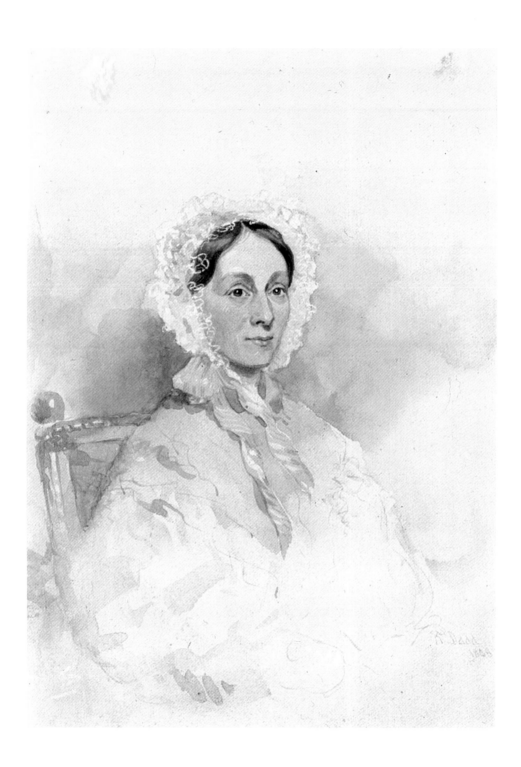

Richard Dadd

(1817–1886)

The Haunt of the Fairies c.1841

Oil on panel
9 × 7½ in (23 × 19 cm)

PROVENANCE
The Maas Gallery, 1972
Private Collection

This painting was shown under the title '*Evening*' in the Tate Gallery's exhibition *The Late Richard Dadd* in 1974. Since then it has been identified as one of two versions of the same subject known as *The Haunt of the Fairies*, both in the possession of the dealer William Cox until his bankruptcy sale in 1884. The larger painting is on canvas, and although virtually identical in all other details it differs substantially in lighting and atmosphere, and in the girl's almost mask-like expression. The present work is clearly a sketch, but whether it is a sketch made for the more finished painting or taken from it afterwards is unclear. Certainly the beguiling little figure seen here might seem more likely to have been painted from a real model, and converted later into her slightly sinister counterpart, than the other way round, but this can only be speculation.

The Haunt of the Fairies, though undated, clearly belongs to the same period as Dadd's first exhibited fairy paintings, the two scenes from *A Midsummer Night's Dream* of 1841, *Titania Sleeping* and *Puck*. Strongly theatrical in concept, with dramatic lighting which may have been influenced by the recent introduction into the theatre of limelight, they are nevertheless closely rooted in the natural world and echo the landscapes with classical figures of an earlier generation. Identifiable as fairies only by the scale of the surrounding plants, the figures could otherwise as easily be nymphs or other deities of the countryside. It is no coincidence that in 1840 Dadd had won the first prize for life drawing in the Royal Academy Schools. An accomplished painter of the nude figure, for which he was particularly commended in reviews of his work, he was also an accomplished landscape painter, and in the fairy paintings he was able to combine the two elements to magical effect. As one contemporary reviewer put it: 'Mr Dadd is emphatically the poet among painters.'

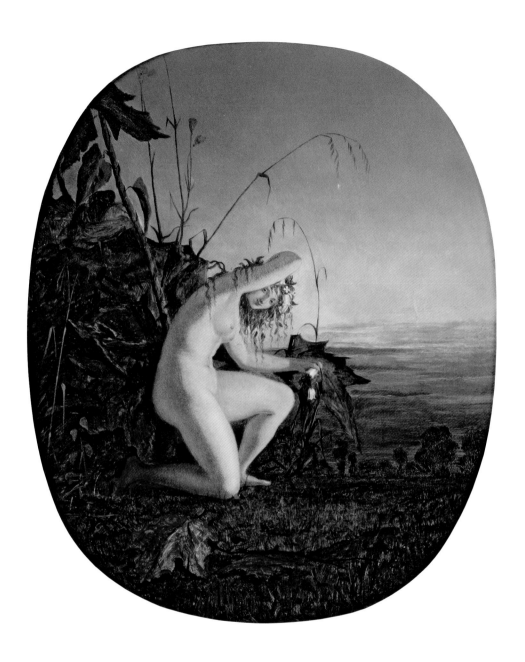

Richard Dadd

(1817–1886)

Portrait of Sir Thomas Phillips in Arab dress 1842/3

Watercolour heightened with white
9½ × 6½ in (24.1 × 16.5 cm)

PROVENANCE
Christie's, 13 July 1993, lot 59
Bethlem Art and History Collections Trust
(Purchased in 1993 with the help of grants from the Art Fund, the Pilgrim Trust
and the MGC/V&A Purchase Grant Fund)

Sir Thomas Phillips (1801–1867) was a lawyer from South Wales where, as mayor of Newport in Monmouthshire, he had come to national prominence and received a knighthood for his role in quelling the Chartist uprising of 1839. He was called to the bar in 1842. Already an experienced traveller, he decided to make an extended tour of Europe and the Middle East before taking up a new position in London, and took Dadd with him as commissioned artist. Dadd made two exceptionally fine watercolour portraits of his patron, one in Arab and one in Turkish dress, in the course of this journey or shortly after their return to England, although there is no clue in the long and detailed letters which Phillips wrote home as to whether or not he actually wore eastern dress while travelling. The practice had been more or less obligatory a few years earlier for Europeans travelling throughout the Turkish controlled territories, and still remained advisable in some areas. Dadd however described his own travelling outfit as including 'a cap of the country called a fez, with two handkerchiefs, one white and one red, tied round it…a pair of large boots of Russian leather, which I can shake off and on…and, added to this, a white blouse, which is generally stuffed full of little things for the convenience of travelling', which sounds like something of a compromise with local custom.

Throughout the journey Dadd rarely had time to use watercolour, but this portrait clearly represents Phillips during the one period of real leisure when they sailed up the Nile in December 1842 and January 1843, and could therefore have been made at that time. It shows him with the gun which, according to Dadd, he had obtained in Cairo from 'Mr. Riga a little fat man with twinkling bead like eyes…he sold good rice and bad brandy and lent Sir Thos. a very bad double barrelled gun to frighten the birds with, and lest the weapon should prove dangerous he sold him some powder that took a long time to fizz off and gave considerable occupation in cleaning out the touch hole'. According to Phillips the gun was even less of a danger to crocodiles, 'upon whose hide it seems impossible to make any impression. This I lay at the door of the powder…'.

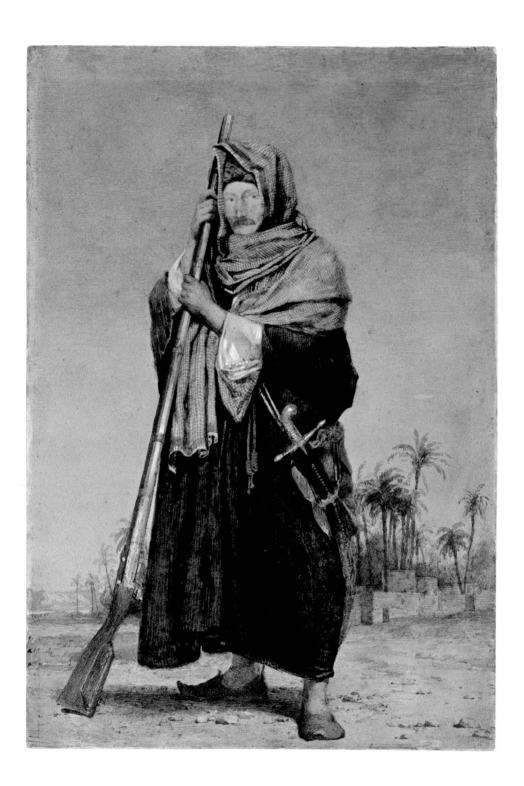

Richard Dadd

(1817–1886)

Minaret of the Great Mosque, Damascus 1842

Signed and dated lower left 'Richard Dadd 1842' and inscribed in pencil on the reverse
'Minaret of the Great Mosque – Damascus'
Watercolour
10 × 7 in (25.5 × 18 cm)

PROVENANCE
Private Collection, Scotland until 2007
Private Collection, England

The real subject of this Damascus street scene, as Dadd's own title written on the back makes clear, is the minaret of the Ommayad Mosque, which reaches up into a pale sky above the shadows and intermittent gleams of sunlight in the street below. Known popularly as The Bride, and the oldest of the three minarets, it stands in the centre of the mosque's northern wall, providing an exact location for the picture. This is the only watercolour depicting a scene from Dadd's Middle Eastern travels which was undoubtedly made during the journey itself (though this can be assumed of several others), being the only one to be dated. It is also likely that it was made while Dadd and Phillips were still in Damascus, where they stayed from 4–9 November, rather than at a later stopping place.

Whether it could have been made on the spot is another matter. Writing to Frith a little later, Dadd recounts some of the hazards of drawing in the street. 'The most serious of all the inconveniences I have met with is that of the curiosity of the people, which has frequently compelled me to desist from sketching what I have been most desirous to obtain. At Damascus especially this was the case, and I have had a crowd of some hundred people gaping about me – those close to me turning over the leaves of one side of my book, I drawing on the opposite side of it; and those further off content with staring at me as if I was a curiosity…' On one occasion he was even followed by the crowd, and pelted with corn husks.

The sketchbook in the Victoria and Albert Museum contains a hasty drawing of the same street, so rough and incomplete by Dadd's normal standards that it could have been made under any or all of the provocations described above; but a more detailed drawing of the minaret, taken from a different viewpoint and probably from the safety of an upper room, appears elsewhere. The carefully grouped figures have evidently been rounded up from different sources, though only one has so far been identified in the sketchbook, the female figure in white, who appears as an isolated figure and sketched only in the briefest outline.

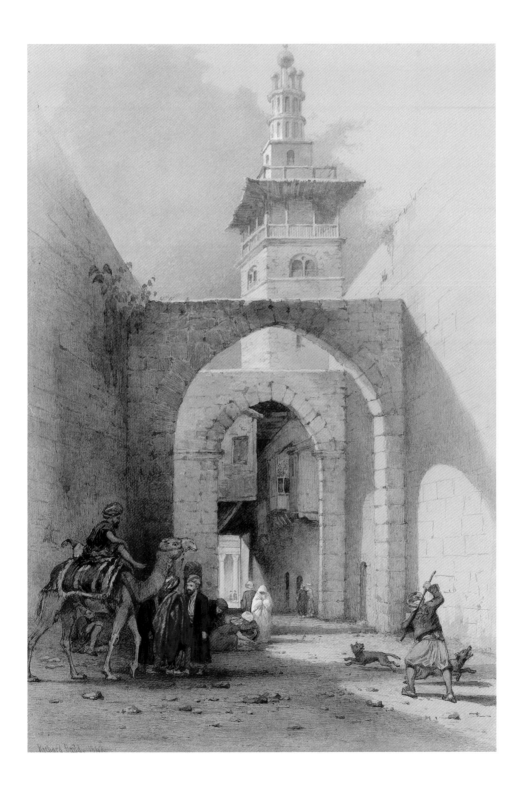

Richard Dadd

(1817–1886)

Letter from Damascus 5 November 1842

In planning his journey of 1842/3 Sir Thomas Phillips consulted David Roberts RA, who had recent experience of travelling in Palestine and Egypt, and also sought his advice about taking an artist with him to make drawings. Roberts, a friend of Dadd's father, recommended Richard Dadd, knowing (in the words of W.P. Frith) 'that the young artist's powers as a draughtsman, and his amiable qualities as a man, would render him as charming in companionship as he would be efficient as an artist.' Roberts was of course devastated by the ensuing tragedy.

Three of Dadd's letters to Roberts have survived, written from Athens, Damascus and Malta. All were published in the *Art Union* in 1843. As the editor commented, 'They are evidence of his astonishing industry, close observation, untiring energy, and enthusiastic love of his profession.' The letter from Damascus, seen with hindsight, also contains evidence that he was already beginning to feel puzzled by, if not actually concerned about,his own state of mind.

Damascus. Novr. 5th . 1842.

My dear Sir

I am glad of the opportunity which occurs of writing to you as doubtless you will desire to know how far I have profited by your assistance in the visiting these countries… As you promised me before starting the interest of these places is intense and when one enters their streets the quantity of character is distracting, so much so as to hinder me from sketching for I could not make up my mind what to do amidst so much to be done. Asia Minor has been the source of much pleasure to me and the cities with their singular tombs would I am certain have proved the source of as much to you. The site of their enormous ruins is remarkable for the romantic and grand; one thing cannot fail to suggest itself to the mind namely the great wealth and power of the people that could do such works…

…The plain and mountains about the city [Macri – now Fethiye] are exquisitely beautiful, and the Masicyths range of snow mountains when first we caught sight of it, was enough to make one leap out of one's skin. Owing to the heat of these climates the snow is not persistent for the whole year and the sight of their bald summits glowing and gleaming in the setting sun, would wake all the artist in you or indeed anybody that has the least love of nature. By artist, understand me as wishing to say enthusiast for no man is an artist without a strong feeling of enthusiasm for his profession. I am not afraid to repeat your own phrase to you, because I'm sure that it is true, as I always find the love of art strongest in me when most enthusiasm would predominate. You see, Sir, that I give you back your own speech merely for the pleasure of flattering myself, a weakness I trust to your kindness to excuse. But I should really fear to say how much I feel on seeing all the treasures of earth that I have so lately witnessed, the big cities and big mountains, the big clouds and deep blue sky where seems to be written in brightest colours the symbol of eternity. See now if my enthusiasm has not already betrayed me into writing what it would puzzle me to explain…

Damascus. Nov.^r 5th 1842.

My dear Sir

 I am glad of the opportunity which occurs of writing to you as doubtless you will desire to know how far I have profited by your assistance in the visiting these countries. Since I wrote to you last we have seen part of Asia Minor and are thus far in the bowels of the land. We have had splendid weather for our journey and until some 2 or 3 days since have scarcely known the signs of a storm. Smyrna you must know well enough to be at all interested in my description of it - but I may say that it is as dirty as ever and was full of bustle and life. The fig season was but just concluded when I was there and we saw but little in the matter comparatively speaking. As you promised me before starting the interest of these places is intense and when one enters their objects the quantity of character is distracting, so much so as to render me trembling for I could not make up my mind what to do amidst so much to be done. Asia Minor has been the source of much pleasure to me and the cities with their singular tombs would I am certain have proved the source of as much to you. The site of their enormous ruins is remarkable for the romantic and grand, one thing cannot fail to suggest itself to the mind namely the great wealth and power of the people that could do such works. The tombs cut from the solid rock are of curious design and seem almost all of them to be destined to contain 3 bodies. At Macri are some of elaborate work and those cut into the rock are more beautiful or rather more architectural than the others we have seen. But it is at Xanthus that the most ornamental of their works are to be found and you will doubtless ere long see some of the sculpture that has been taken thence under the superintendance of M.^r Fellows. Whatever may be the origin of their school of art it bears in some instances a strong resemblance to Egyptian works and I have seen sketches made by a M.^r Forbes and have sketched a sculptured tomb that leave but little doubt on my mind as to their resemblance can do away with it. But as the learned are at variance on this point it would ill become their venture an opinion upon the matter. At Xanthus the tombs are chiefly built and the sarcophagi proved a source of wealth. Mair superior to that of any other in the parts indicate replaced by travellers. Macra is a most extraordinary place the rocks of many hundred feet high tower above the city and their face is covered with the excavations of the tombs. Nothing can be more extraordinary than these tombs the situation and design are scarcely to be realise to a degree. Those at Macri which I spoke of above are of a low loose order and yet the execution of the work is of a superior description. The theatre here is in fine preservation but the seats are well enough; around about it are the sculptured niches or their body pieces sculptured I say because nothing of them remains but the face which is cut in the solid rock. The sea washes the shore nearly close to the entrance of the theatre and across the bay you may still see the ruins of another more modern city called by the same name but which I believe is not worthy of attention at all considering it architecturally. The plain and mountains about the city are exquisitely beautiful and the majestic range of snow mountains when first we caught sight of it was enough to make one leap out of ones skin by going to the heat of their climates the snow is not persistent for the whole year and the tops of their bald summits glowing and gleaming in the setting sun would wake all the artist in you or indeed any body that has the least love of nature. No artist understand me as wishing to say that no man is an artist without a strong feeling of enthusiasm for his profession. I am not afraid to express your own phrase to you because I am sure that it is true, as I always find the love of art strongest in me when

Richard Dadd

(1817–1886)

Jerusalem from the House of Herod 1842/3

Inscribed by the artist in pencil on the reverse 'Jerusalem from the House of Herod'
Watercolour
6½ × 10 in (16 × 25.5 cm)

PROVENANCE
Private Collection, Scotland until 2007
Andrew Clayton-Payne
The Morgan Library & Museum, New York
Purchased from the Sunny von Bülow Fund 1978

This exquisite view of Jerusalem, seen from the north and bathed in radiant light from the western sun, has been protected in an album for most if not all of its existence and survives in pristine condition. The depth and intensity of both the colour and the vision, so reminiscent of Palmer, may surprise anyone more familiar with the pale, delicate watercolours produced in Bethlem and Broadmoor, but it clearly shows the qualities which had helped to establish Dadd's early reputation for the outstanding 'power, fancy and judgement' of his work.

Dadd reached Jerusalem with Sir Thomas Phillips on 20 November 1842, after they had spent eleven days touring the Holy Land on the way from Damascus. The following morning they set out on an excursion to the River Jordan and the Dead Sea, and left again three days after their return. He therefore had no more than two full days, or three evenings, to find the location for this view of the city, make a preparatory sketch, study the light and, if he did not complete it until later, absorb and store the essentials in his memory. A pencil drawing of the identical view survives in his sketchbook in the Victoria and Albert Museum, but contains neither colour notes nor any indication of the lighting effects which transform a highly competent topographical drawing into this most magical of sunsets.

His vantage point looks south over the Temple Mount past the Dome of the Rock to the El-Aqsa Mosque, and round to the west across the domed roofs of the old city, against a backdrop of the Kidron Valley and surrounding hills and mountains. His note on the back of the picture, 'Jerusalem from the House of Herod', evidently refers to what was then erroneously thought to be the site of Herod's Palace, on high ground just north of the Via Dolorosa. From here he has been able to look slightly down on a panoramic view of the town which dips away from Temple Mount and gently rises again to the west, and to use the massively built and heavily shadowed barracks in the foreground as a dramatic foil for his fairytale city which almost floats into the late evening sunlight beyond. An inspired touch allows the majestic Dome of the Rock to be dwarfed and literally sidelined by the sturdy presence of the Ghawanima Minaret, which stands on the boundary between light and shade to become the focal point of the composition.

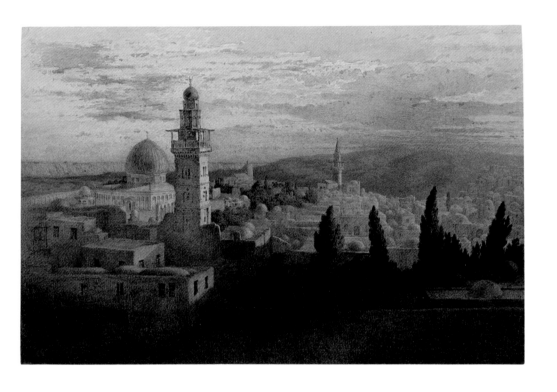

Richard Dadd
(1817–1886)

A Dream of Fancy 1859

Inscribed and dated lower centre 'A Dream of Fancy. Rd Dadd. Bethlem Hospital 1859'
Watercolour
3¾ × 5¾ in (9.9 × 14.6 cm)

PROVENANCE
G.H. Haydon, probably given to him by the artist
Given by Haydon to Myles Birket Foster
Sotheby's, 2nd November 1966, lot 198
Private Collection

Writing of one of Dadd's early fairy paintings, a contemporary reviewer wrote that 'He seems to paint in a dream; but it is a dream in which the images are all naturally arranged.' It is possible that Dadd might have recalled the comment when he chose to emphasise the 'dreamlike' character of this haunting little landscape by calling it *A Dream of Fancy,* a title which he used again in French for *Songe de la Fantasie,* the watercolour version of *The Fairy Feller's Master-Stroke* which he painted after his removal to Broadmoor. In the late 1850s, after working on other subjects for a few years, he seems to have returned to making landscape drawings associated with his travels, but in a more remote and visionary style than the earlier ones, and using a fine technique of stippling which gives them an extraordinary delicacy. Sometimes they are worked directly from sketches made on the spot, sometimes partly or wholly from memory, and sometimes, as here, they are purely imaginary, though obviously composed of elements derived from both memory and sketches. All might justifiably be called 'dreams of fancy'.

This drawing belonged at one time to the painter and illustrator Myles Birket Foster, to whom it was given by G.H. Haydon, the steward of Bethlem Hospital who was himself an amateur artist and friend of many professionals. It is no surprise that this enchanting and enchanted landscape should have appealed to Birket Foster, who had independently developed a similar stippling technique for his own landscapes which he himself described as 'very peculiar', but which he used with great success. After the picture appeared in the Tate exhibition of 1974 it was also admired by the glass engraver Laurence Whistler, whose work in a very different medium shares qualities both of texture and of poetic intensity with the most ethereal of Dadd's watercolours.

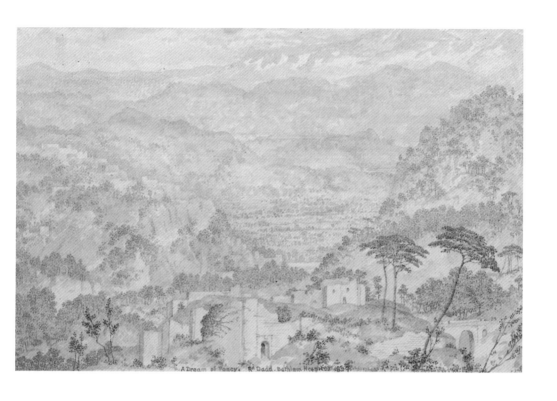

A Dream of Fancy. R^d Dadd. Bethlem Hospital 185?

Richard Dadd

(1817–1886)

Reminiscence of the River Medway at Chatham 1857

Inscribed upper right 'Reminiscence of the River Medway at Chatham –
Scene from the Sun /Quay – Yarmouth Bloater – Boat departing.&c. by Richard Dadd: Bethlehem Hospital.
/St. George's in the Fields. London. July 20th. 1857. Juvat ire per undas.'
Pencil and watercolour
7 × 10 in (17.7 × 25.4 cm)

PROVENANCE
(Probably) Sir Charles Hood to 1870.
(Probably) Christie's 28 March 1870, lot 309 bt. Holloway
Mrs D Cuthbert to 1964
Christie's, 8 December 1964, lot 183
Private Collection

Dadd's meticulous inscription at the top of this watercolour amounts almost to a catalogue entry in its own right: 'Reminiscence of the River Medway at Chatham – Scene from the Sun Quay – Yarmouth Bloater-Boat departing &c....' The subject is lovingly recalled from his childhood in Chatham, and had he wished, there can be little doubt that he could also have catalogued all the other craft depicted here on the river, as well as every stick and stone along the banks on either side, despite the fact that it could not have been less than fifteen years since he last saw this view.

The Sun Quay was one of numerous wharves and quays providing access to the Medway from the streets of Chatham, and was the one closest to the Dadd family's home in the High Street. On the tip of one of the river's hairpin bends, it was an ideal vantage point for views up river to Rochester and, as here, down past the parish church (now much altered) to the dockyard on the right, and on to Upnor on the left. The hulls of the large ships in the distance are probably not (as once suggested) the prison hulks which feature in Dickens's *Great Expectations*, but the men-of-war moored in the river adjacent to the dockyard, where they were fitted out. Dadd must have frequently sketched and studied the shipping from here throughout his early life, and although he could have had sketches with him in Bethlem, he has been pedantically careful elsewhere in noting the fact when drawings have been taken 'from a sketch made on the spot'. In the absence of such information, it seems likely that this vividly evoked scene is truly a 'reminiscence' as suggested in the title.

The inscription ends with the Latin sentence, 'Iuvat ire per undas' ('It is pleasing to go through the waves'). This appears to be a half quotation from Virgil's Aeneid, 'Iuvat ire sub umbras' ('It is pleasing to go down to the shades'), spoken by Dido in her death scene as she is about to immolate herself on a funeral pyre. Although this is almost certainly what Dadd had in mind, it would have been so inappropriate in the present context that he must be deliberately playing with the words rather than simply mis-quoting them.

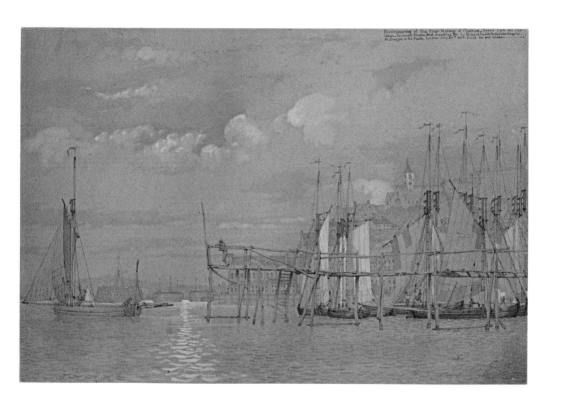

Richard Dadd

(1817–1886)

Portrait of John McDonald (?)1857/64

Watercolour

15½ × 10¾ in (40 × 27.5 cm)

PROVENANCE

Sotheby's, 14 July 1988, lot 10

Peter Nahum, 2002

Bethlem Art and History Collections Trust (Purchased in 2002 with the help of a grant from the Art Fund)

John McDonald was an attendant at Bethlem Hospital, not in the Criminal Department where Dadd was originally housed and where the staff were separately employed, but in the main hospital. He was in charge of the ward which, in 1857, was converted and made secure to accommodate some of the 'better class' of criminal patients, and to which Dadd was transferred along with others in that category. McDonald thus came to be the person who could have most influence on Dadd's daily life, and was rewarded with one of his finest and most sensitive portraits.

Its reappearance in 1988 showed that there are still new and exciting facets of Dadd's work to be discovered. Although he was known to have painted three substantial portraits in oil during his time in Bethlem and Broadmoor, nothing comparable to this strong and assured drawing was known to exist. Least of all was it know that he had ever painted portraits using the fine stippling technique which he developed into such a highly personal style while he was in Bethlem, but which was previously associated only with his most delicate and visionary images of memory and imagination. Combined here with touches of wash and minutely fine drawing with the point of the brush, it shows his complete mastery of all three techniques and unerring judgement in their use.

The lower edge of the paper has been badly damaged, particularly around the signature and date, and the date is now completely illegible. The year was read as '[18]74' when the picture was first discovered, which would have meant that it was painted in Broadmoor. While it is possible that Dadd worked at least partly from a photograph, which could account for the unfinished lower part of the legs, and it could therefore have been painted after he left Bethlem, the proposed 1874 date seems unlikely for a number of reasons.

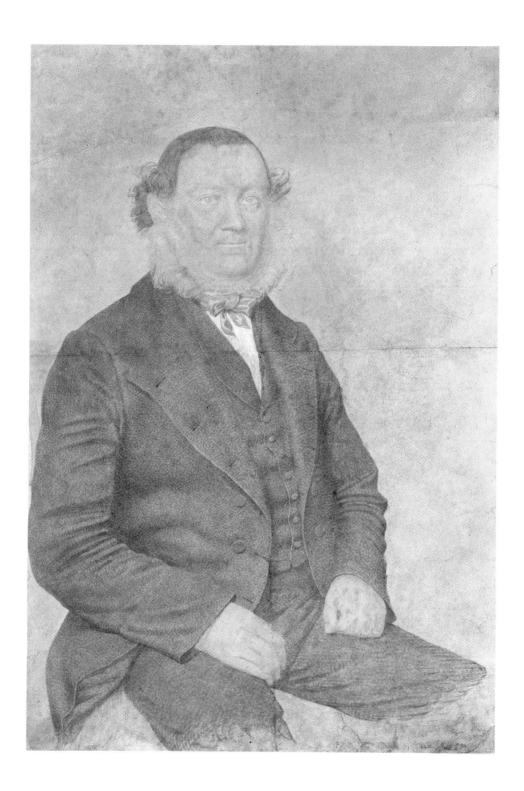

Richard Dadd

(1817–1886)

Sketch of an Idea for Crazy Jane 1855

Inscribed upper left 'Sketch of an idea for Crazy Jane./by Richard Dadd. Bethlehem Hospital. London
[August *expunged*] September 6th . 1855.'
Watercolour
14⅛ × 10 in (36 × 25.6 cm)

PROVENANCE
Bethlem Art and History Collections Trust

This is one of Dadd's most lyrical figure drawings, and seems to symbolise his fellow-feeling for the outcast and the hopeless. It illustrates the central character from the popular ballad 'Poor Crazy Jane', a girl who wanders the countryside after being driven mad by the desertion of her false lover, though Crazy Kate, who features in similar stories and was painted by Fuseli and others, was probably better known. As in the 'passions' drawing *Melancholy*, the mood is created through colour and composition, and again a ruined castle adds a sense of desolation to the landscape, as do the circling rooks which, with their black colouring, are sometimes seen as harbingers of doom. Some of Dadd's finest drawing can be found in such details as the broken stalks of wheat and the ribbons and feathers with which the girl has festooned herself. Her face, which seems more male than female, may have actually been modelled on a man, whether remembered or someone in the hospital. Even in the main hospital the male and female patients were strictly segregated, though they did sometimes meet, but in the criminal department Dadd would not have seen any women except occasional visitors for many years.

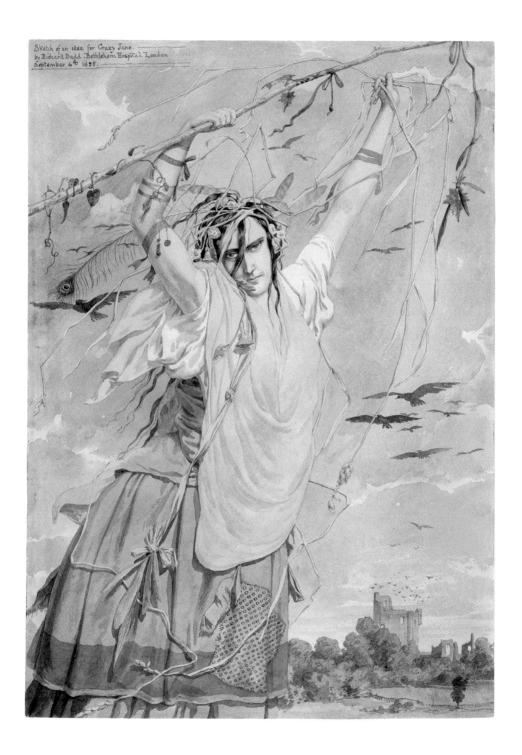

Sketch of an idea for Crazy Jane.
by Richard Dadd. Bethlehem Hospital. London
September 6th 1855.

Richard Dadd
(1817–1886)

Lucretia 1854

Inscribed lower left 'Lucretia – a Sketch/ by Richard Dadd 1854/July 24th . Bethlehem Hospital London.'
Watercolour
12 × 10 in (30.5 × 25.4 cm)

PROVENANCE
Bethlem Art and History Collections Trust

The story of the rape and suicide of the Roman noblewoman Lucretia would have been well known to Dadd from the many times it has been painted, and perhaps also from his classical reading, or from Shakespeare's poem *the Rape of Lucrece*, but there is no clue as to why he has chosen to portray her himself on this occasion. A legendary heroine of ancient Rome, she was also a symbol of female virtue, and it is possible that he originally chose the subject for inclusion in the 'Passions' series.

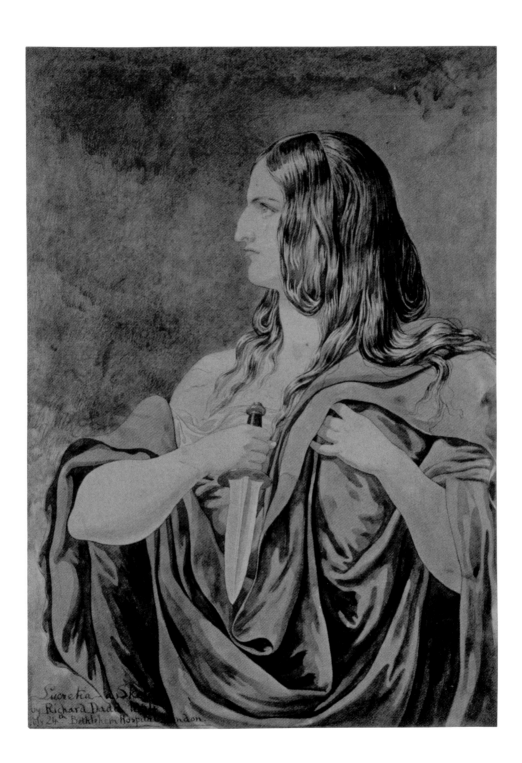

Lucretia a Sk...
by Richard Dadd ...
...ly 24th Bethlehem Hospital...ndon.

Sketches to Illustrate the Passions

Dadd appears to have begun his long series of 'Sketches to Illustrate the Passions' in 1853, though earlier examples may be lost. The fact that the reforming physician superintendent Sir Charles Hood was appointed to Bethlem Hospital in this year has led to speculation (and sometimes assertion) that Hood suggested the subject as some sort of therapeutic exercise, for which there is no evidence of any sort, either way. However, Hood was certainly interested in these works, since he owned fifteen of them out of a total of thirty three drawings and paintings by Dadd which were sold after his death. The subject matter, including historical and literary scenes and scenes from everyday life, and the technique of crisp outlines with broad washes of colour, is indistinguishable from that of 'non-passions' drawings from the same period, but after the 1850s he hardly seems to have worked in this style at all. The word 'sketch' seems often to have the double meaning of a drawing and a brief dramatic interlude, and a few of the early examples are actually scenes from Shakespeare.

As a subject of particular interest to painters, 'the passions' may well have featured in lectures at the Royal Academy Schools, and Dadd was probably familiar with Williams Collins's *Ode to the Passions*, passages in Thomas Gray's *Ode on a Distant Prospect of Eton College,* and other literary sources. Nineteenth century discussion on the subject ranges widely through the fields of medicine, theology, psychology, art, philosophy and elsewhere, though without necessarily clarifying it to any great extent for present purposes. However, it would doubtless be possible to come up with a central core of 'passions' which most people would have recognised, although Dadd's selection seems at times to be pushing the boundaries as it drifts towards more general abstract concepts. The series seems to have been largely completed in 1853 and '54, with a few more in 1855 and two in 1856 and '57. More may yet be discovered, but those found so far are: Jealousy; Love; Hatred; Poverty; Splendour & Wealth; Treachery; Gaming; Idleness; Brutality; Pride; Ambition; Agony – Raving Madness; Drunkenness; Avarice; Melancholy; Insignificance or Self Contempt; Self-Conceit or Vanity; Deceit or Duplicity; Disappointment; Anger; Murder; Grief or Sorrow; Battle or Vengeance; Fanaticism; Senility or Peevishness; Recklessness; Suspense or Expectation; Want, the Malingerer; Patriotism. Three more are known only by name: Malice; Despair; Ingratitude.

opposite
RICHARD DADD (1817–1886) *Sketch to Illustrate the Passions. Brutality* 1854 (detail)
watercolour 14¼ × 10 in (36.2 × 25.4 cm)

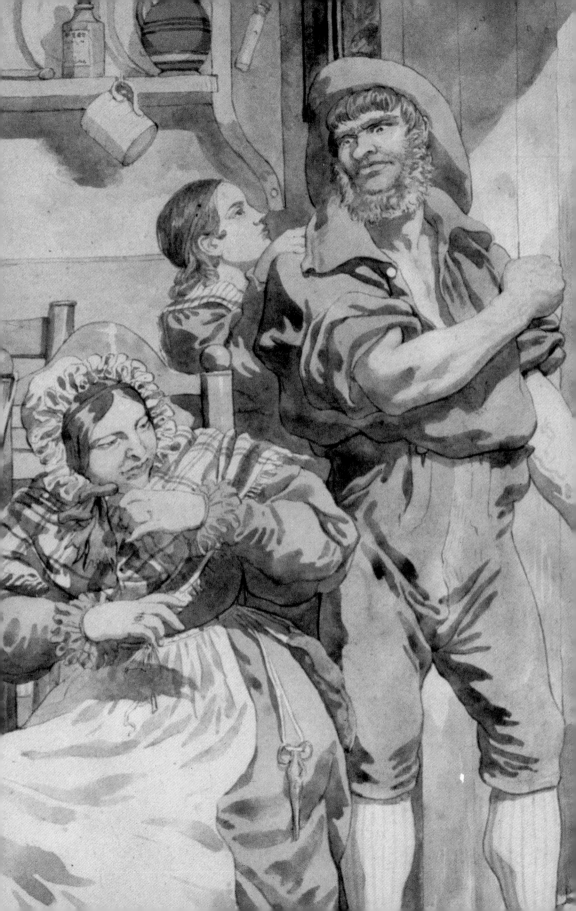

Richard Dadd

(1817–1886)

Sketch to Illustrate the Passions. Deceit or Duplicity 1854

Inscribed across bottom of the sheet 'Sketch to illustrate the Passions/Deceit or Duplicity – by Richard Dadd
Bethlehem Hospital. London. September 15th. 1854.'
Watercolour
14½ × 10¼ in (36.5 × 26 cm)

PROVENANCE
Bethlem Art and History Collections Trust

This is one of the more baffling of the 'Passions' drawings, though the general message seems to be
that the world is full of deceit and duplicity. It seems at first sight to represent an ugly old woman
hiding her face behind the mask of a beautiful young girl, but judging by her arms and feet she seems
to have the body of a young girl too. Nor is it clear why the scene seems to be taking place in some
kind of vault, or what the strange looking chair might be made of: or why the small picture of Eve
being tempted by the serpent is apparently hanging on the side of it.

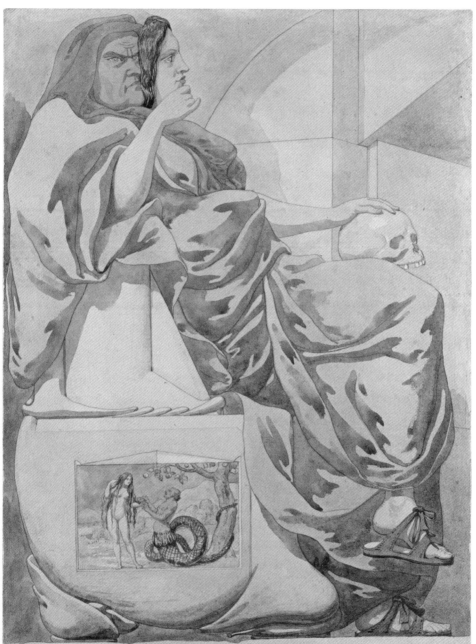

Sketch to illustrate the Passions ———— Deceit or Duplicity ———— by Richard Dadd Bethlehem Hospital London . September 15th 1854 ~

Richard Dadd
(1817–1886)

Sketch to Illustrate the Passions. Brutality 1854

Inscribed lower left 'Sketch to illustrate the Passions. Brutality. Richd Dadd. Bethlem Hospital. London. 1854'
Watercolour
14¼ × 10 in (36.2 × 25.4 cm)

PROVENANCE
Sir Charles Hood to 1870
Christie's, 28 March, 1870, lot 326 (unsold)
Given to Bethlem Hospital by Mrs Wormald in 1924
Bethlem Art and History Collections Trust

Throughout his time in Bethlem and Broadmoor Dadd rarely painted scenes in interior settings, though several occur in the 'Passions' drawings. Domestic interiors are even more rare, and seem likely to be places which he could have remembered from his childhood and had possibly already painted, such as this simple fisherman's cottage.

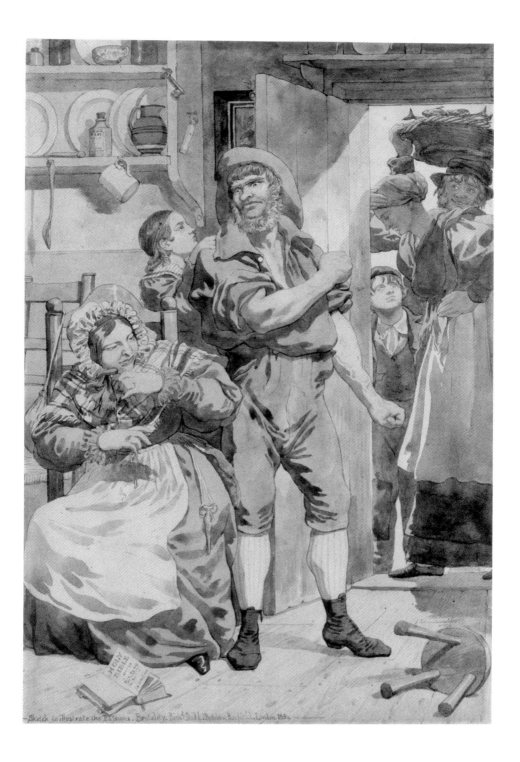

Sketch to illustrate the Passions. Brutality. First Dah. William Bayes. London. 185-

Richard Dadd

(1817–1886)

Sketch to Illustrate the Passions. Murder 1854

Inscribed lower left 'Sketch to illustrate / The Passions/ Murder. Cain murders Abel/ by Richard Dadd
Octr 24. 1854/ Bethlehem Hospital. London'
Watercolour
14¼ × 10¼ in (36.2 × 26 cm)

PROVENANCE
Bethlem Art and History Collections Trust

Although Dadd himself and quite a number of his companions had a close personal knowledge of the subject of murder, he has chosen here to show the archetypal murder story of Cain and Abel. He was not reluctant to talk about his own act of murder, even late in life when he was in Broadmoor, but it seems that here and elsewhere he is generally able to disengage his professional life as an artist from other aspects of his situation.

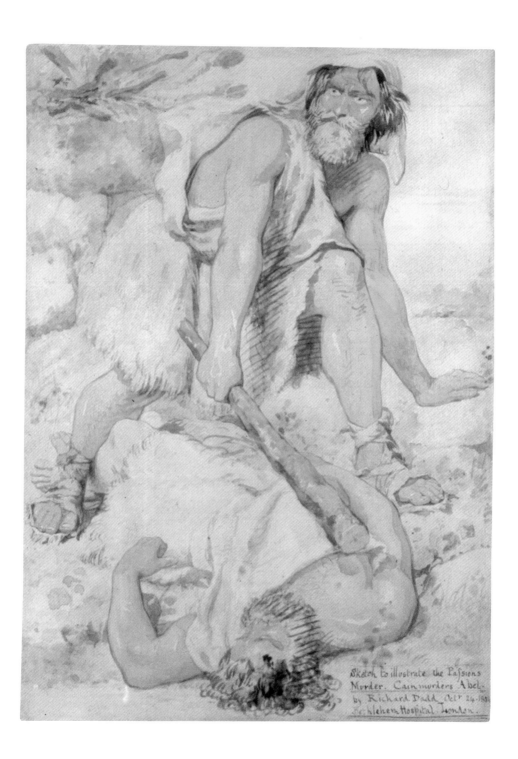

Sketch to illustrate the Passions
Murder. Cain murders Abel,
by Richard Dadd. Oct 24 18
Bethlehem Hospital, London.

Richard Dadd
(1817–1886)

Sketch to Illustrate the Passions. Agony – Raving Madness 1854

Inscribed lower left 'Sketch to illustrate the Passions. Agony – Raving Madness./by. Richard Dadd.
Bethlem Hospital London. May 2nd 1854'
Watercolour
14 × 9¾ in (35.5 × 25.3 cm)

PROVENANCE
Bethlem Art and History Collections Trust

In portraying madness, Dadd could have taken any of his daily companions as a model and shown them in the contemporary setting which he knew all too well – something which in fact he seems never to have done throughout his years in Bethlem and Broadmoor. He has chosen rather to use what seems at first to be the universal stereotype of a chained lunatic lying on a bed of straw, but has made it into a deeply personal expression of his own condition, struggling not against the loosely hanging chains but against the agony of his own tormented mind.

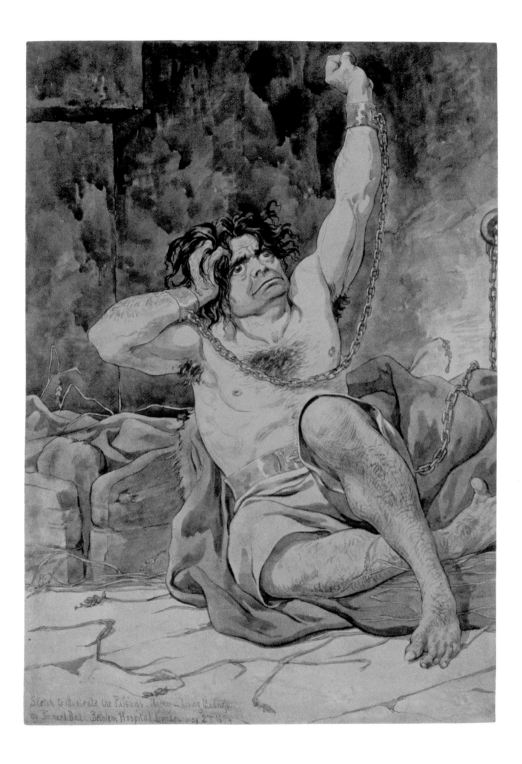

Sketch to illustrate the Passions . Mania - Raving Madness.
By Richard Dadd. Bethlem Hospital, London, may 2nd 1854.

Richard Dadd
(1817–1886)

Sketch to Illustrate the Passions. Battle or Vengeance 1854

Inscribed and dated lower left 'Sketch to illustrate the Passions.Battle/or Vengeance. By Richard Dadd.
Bethlem Hospital./London Decr 4th. 1854'
Watercolour
14¼ × 10 in (36.2 × 25.4 cm)

PROVENANCE
Bethlem Art and History Collections Trust

Dadd's careful, sometimes over-careful method of composition does not always lend itself to crowded scenes of action, but here he has been remarkably successful in conveying the clash of combat. Although he cannot have had any of the artist's normal studio props with him in Bethlem, let alone a suit of armour, a number of pictures show his liking for painting armour and historic weapons of all kinds, and here he is particularly convincing. As medievalism was growing in popularity during the period when he was a student, he may have acquired both the taste and the skills at that time.

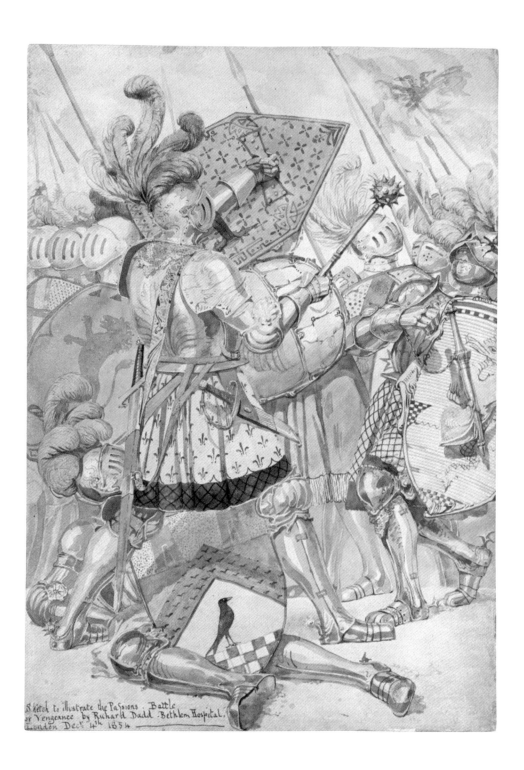

Sketch to illustrate the Passions. Battle of Vengeance by Richard Dadd. Bethlem Hospital. London Dec.r 4th 1854

Richard Dadd

(1817–1886)

Sketch to Illustrate the Passions. Insignificance or Self Contempt 1854

Inscribed lower left 'Sketch to illustrate the Passions. Insignificance or/Self Contempt –
Mortification – Disgusted with/the world –he sinks into himself and Insignificance. – Richard Dadd.
Bethlehem Hospital. London. July 12th. 1854.'
watercolour
14 × 9⅞ in (35.6 × 25.3 cm)

PROVENANCE
Bethlem Art and History Collections Trust

The exact subject of this picture is unclear, except that the small baggy figure appears to be a caricature of J.M.W. Turner, whom Dadd would have seen in his student days at the Royal Academy. The most straightforward interpretation would be that it is about the lowly and insignificant status of the artist: but that would not quite account for Dadd's sudden outburst of emotion in the text of the inscription, which begins in his usual neat hand by stating the picture's title, 'Insignificance or Self Contempt' and then breaks into a more hurried and agitated script as though some other thought has taken over, 'Mortification – Disgusted with the world – he sinks into himself and Insignificance'. This suggests some deeper personal meaning.

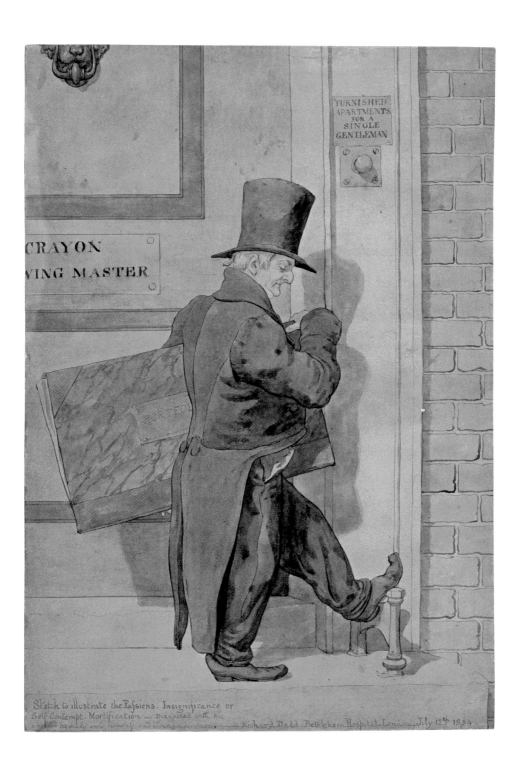

Richard Dadd
(1817–1886)

Sketch to Illustrate the Passions. Melancholy 1854

Inscribed lower left 'Sketch to illustrate the Passions. Melancholy./by.Richard Dadd.
Bethlehem Hospital. London. May 30th. 1854'
Watercolour
14⅜ × 10 in (36.5 × 25.5 cm)

PROVENANCE
Dr Isobel Simpson
Sotheby's 15th July, 1964
Private Collection

This is perhaps the most successful of all Dadd's 'Passions' sketches in the simple directness with which it conveys its theme, creating an atmosphere of gentle melancholy mainly through design and colouring without the narrative content on which many of the others rely. The solitary pilgrim gazes out from an empty shore towards what must surely be an equally empty horizon, his languid body melting into the curve of the bare rock against which he rests, while in the background a slate-grey sea laps almost audibly onto the beach. On top of the tall and featureless crag behind him is a ruined castle, combining two leitmotifs which recur in many of Dadd's works and here contribute an air of desolation to the landscape.

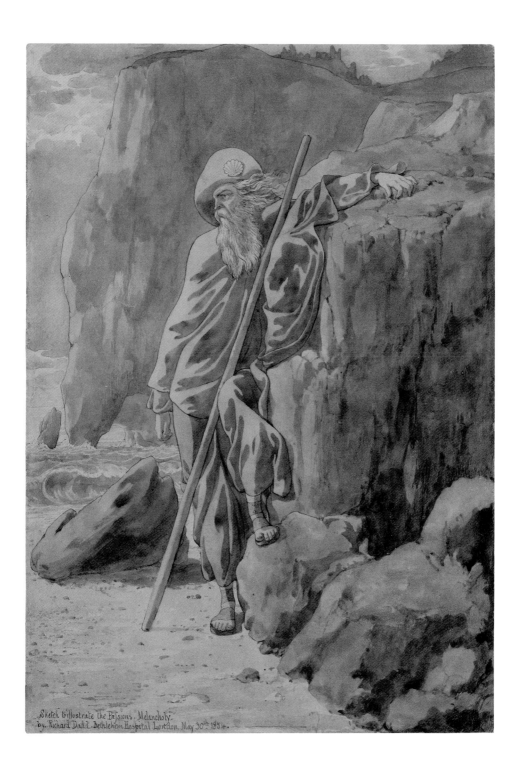

Sketch to illustrate the Passions. Melancholy.
by. Richard Dadd. Bethlehem Hospital London. May 30th 1854.

Richard Dadd
(1817–1886)

Sketch to Illustrate the Passions. Grief or Sorrow 1854

Inscribed lower left 'Sketch to illustrate the Passions/Grief or Sorrow/by Richard Dadd –
/Bethlehem Hospital/London/Novr 7th/ 1854'

Black and grey wash
14 × 10 in (35.6 × 25.4 cm)

PROVENANCE
Bethlem Art and History Collections Trust

Like the 'passions' sketch *Melancholy*, this evocation of Grief shows Dadd to be at his most effective in this series when portraying the more sombre and introspective emotions rather than the violent ones. His skilled use of lighting to create a strong sense of presence is reminiscent of the theatrical effects seen in the early fairy paintings, though used here to very different ends, and the woodland setting also seems to hark back to his early engagement with the world of nature.

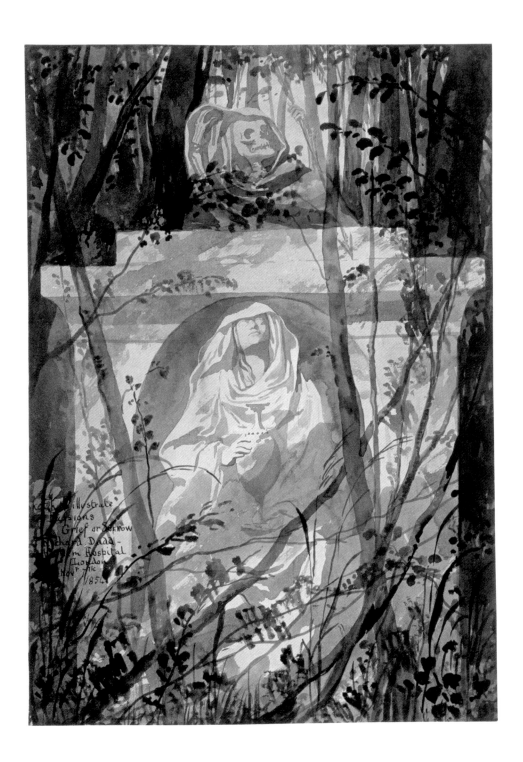

Epilogue

'A person more invariably gentle, kind, considerate, and affectionate, did not exist. He was emphatically one who could not deliberately injure a fly.'

(*Art Union*, October 1843)

.

'His personal appearance was in his favour. He was somewhat tall, with good and expressive features, and gentlemanly demeanour. His career afforded sure promise of a great future – suddenly blighted by a terrible fate.'

(S.C. Hall, *Retrospect of a Long Life*, 1883)

'No living artist possessed a more vivid or delicate imagination'

(*Art Union*, October 1843)

'Dadd was, during my knowledge of him, a man of strong common-sense, the reverse of flighty or excitable in his conversation; and, in my judgment, the last man of my acquaintance likely to suffer from the affliction which destroyed him.'

(W.P. Frith, *My Autobiography and Reminiscences*, 1888)

'How many times I have thought over the 'clique,' with all its associations of fun and frolic mixed – certainly with a big grain of folly, I need not assure you. Often I am with you in fancy, discussing the merits of our immortal art, immortal through Raphael and his gang of compeers. How fine this would sound to another than an artist, but to him how true!'

(Richard Dadd, letter to W.P. Frith, 26 November 1842)

'All who knew him speak of the exceeding gentleness and sweetness of his nature, which, though sensitive, was anything but irritable; he was satisfied with small praise for himself, but ready and lavish of his praise of others.'

(*Art Union*, October 1843)

'I am perfectly satisfied with Mr Dadd, who is obliging, good tempered, sufficiently informed on general subjects to make an agreeable companion, possesses considerable knowledge of art & loses no opportunity to improve himself.'

(Sir Thomas Phillips, letter from Athens, 3 September 1842)

'Oh, such expression! oh, such heads! enough to turn the brain of an artist.'

(Richard Dadd, Letter to David Roberts 4 September 1842)

'At times the excitement of these scenes has been enough to turn the brain of an ordinary weak-minded person like myself, and often I have lain down at night with my imagination so full of wild vagaries that I have really and truly doubted of my own sanity.'

(Richard Dadd, letter to W.P. Frith, 26 November 1842)

'…you can't be wrong in staying your poor deluded steps in any part of this emporium of artistic wealth. I wish I had the gigantic powers of a Shakespeare, an Otway, or any other way, to tell you of the big feelings that the sight of these things generates in me…'

(Richard Dadd, letter to W.P. Frith, 26 November 1842)

'[In Cairo] I walked about the streets with my eyes and mouth wide open swallowing with insatiable appetite the everlasting succession of picturesque characters, I had the most unac-countable impulses that would not let me stop to sketch but were constantly prompting me on to drink in with greedy enjoyment the stream of new sensations.'

(Richard Dadd, letter to David Roberts, 24 February 1843)

'With you I feel that Dadd's was no common mind & that in professional capabilities he had left far behind him all the men of his own standing & position.'

(Sir Thomas Phillips, letter to David Roberts, 16 September 1843)

'We must now number among the departed, one of the kindest and the best, as well as the most gifted, of the children of genius it has ever been our lot to know.'

(*Art Union*, October 1843)

'Here also poor Dad [*sic*], the artist who killed his father…is obliged to weave his fine fancies on the canvas amidst the most revolting conver-sation and the most brutal behaviour.'

(*The Quarterly Review*, 1857, article on Bethlem Hospital.)

'Mr Dadd was probably the only person in England who believed in Osiris; had there been a few hundreds or even a few scores of persons entertaining the same belief, his ideas on this subject would have been of infinitely less value as a symptom of insanity.'

(Dr J.C. Bucknill, *Unsoundness of Mind in Relation to Criminal Acts*, 1857)

'A recluse doing the honours of his modest unpretending abode; a pleasant-visaged old man with a long and flowing snow-white beard, with mild blue eyes that beam benignly through spectacles…his manner is unassuming, but impressive and perfectly courteous.'

(*The World*, 1877)

'Thank you much for the information [your letter] contained respecting the dear departed. I am truly thankful to know him at rest, it is less grief to me, than it was to think of him in the changed condition in which he has lived for many years past, his life has been to me a living death.

(His sister Mary Ann Dadd, letter to her sister-in-law, 31 January 1886)

'I can truly say, from a thorough knowledge of Dadd's character, that a nobler being, and one more free from the common failings of human-ity, never breathed.'

(W.P. Frith, *My Autobiography and Reminiscences*, 1888)

'Many works will live after him, the product of these…years of absolute seclusion – melancholy monuments of a genius so early shipwrecked, but which never went actually to ruin.'

(Dr J.C. Bucknill, *The World*, 1877)

But whether it be or be not so
You can afford to let this go
For nought as nothing it explains
And nothing from nothing nothing gains

(Richard Dadd, last lines of his poem 'Elimination of a Picture & its subject – called The Feller's Master Stroke', 1865)

Richard Dadd
(1817–1886)
Dreams of Fancy
A Loan Exhibition

Published by Andrew Clayton-Payne
Copyright © Andrew Clayton-Payne 2008
Copyright © Patricia Allderidge text 2008

isbn 978-0-9559480-0-8

Designed by Tim Harvey, London

Printed by Balding + Mansell, Norwich

front cover
Richard Dadd (1817–1886) *Sketch of an Idea for
Crazy Jane,* 1855 (detail), watercolour 14⅛ × 10 in
(36 × 25.6 cm)

back cover
Richard Dadd (1817–1886) *Self-Portrait,* 1841
(detail), etching 5¼ × 4½ in (13.3 × 11.4 cm) (plate)